Northwest Native Arts:
CreativeColors 1

Written and illustrated by
Robert E. Stanley Sr.
The House of Ni'isyuush

hancock
house

ISBN-13: 978-0-88839-532-0
ISBN-10: 0-88839-532-9
Copyright © 2003 Robert E. Stanley Sr.

Second printing 2005
Third printing 2007

Cataloging in Publication Data

Stanley, Robert E., 1958-
 Northwest native arts : creative colors / written and illustrated
by Robert E. Stanley

 "The House of Ni'isyuush".
 ISBN 0-88839-532-9 (v. 1) — ISBN 0-88839-533-7 (v. 2)

 1. Nis_ga'a art—Technique. 2. Indian art—Northwest Coast of North
America—Technique. 3. Animals in art. 4. Color in art. I. Title.
E78.N78S722 2003 704.03'970795 C2003-910239-4

Printed in China — SINOBLE

Editing: Yvonne Lund
Production: Robert E. Stanley Sr.
Cover design: Theodora Kobald

Published simultaneously in Canada and the United States by

HANCOCK HOUSE PUBLISHERS LTD.
19313 Zero Avenue, Surrey, B.C. Canada V3S 9R9
(604) 538-1114 Fax (604) 538-2262

HANCOCK HOUSE PUBLISHERS
1431 Harrison Avenue, Blaine, WA U.S.A 98230-5005
(604) 538-1114 Fax (604) 538-2262

Website: www.hancockhouse.com
Email: sales@hancockhouse.com

Contents

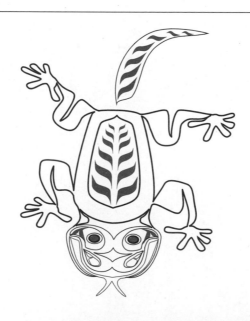

Acknowledgments

I would like to take some time to thank everyone who made this book possible. I have been very fortunate and have received a lot of inspiration from many people.

First of all, I would like to thank my beautiful wife, Donna and my immediate family for all their support.

I would like to say thank you to my dad, Murphy Stanley Sr., and my two brothers, Murphy Jr. and Virgil for all their inspiration. Also, thank you Peter McKay (hlgu-ayee) for the linguistic assistance of the nisga'a names.

I would like to thank the carvers of K'san Village in Hazelton, British Columbia, for helping us with the Northwest Native Arts books. They are: Earl Muldoe, Walter Harris, Victor Mowatt, Roy Vickers, Dempsey Bob, Vernon Stevens, Ron Sabaston, Art Sterrit, Neil Sterrit, Chuck Harris, Herb Greene, Freda Deising and many more.

I really enjoyed watching them work and have received a lot of inspiration from them and their work.

I thank you all,
Robert E. Stanley Sr.

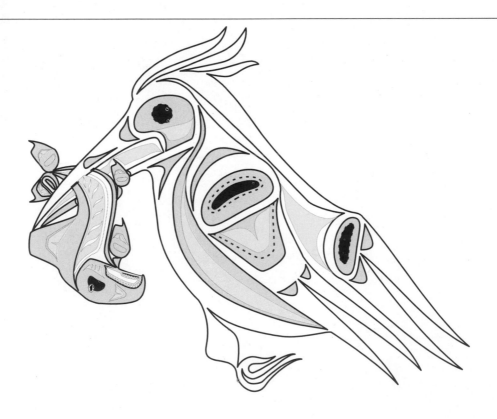

Introduction

Welcome to Creative Colors 1 in The Northwest Native Arts series. I hope that you enjoy coloring these designs. You can color them any color that you choose, but, I would like to express to you that our traditional colors are black and red. The black is used to color in the main form lines of the design. The main form lines are the basic head form lines and the solid U-shape form lines. The red is used to color in the filler designs that are normally placed in the U-shape form lines and cheek designs. These are called the split U-shapes, S-shapes or L-shapes. I will illustrate where these colors are supposed to be placed, then, you can decide on your own what colors you will use.

The illustration on this page is to demonstrate where the colors are placed. The gray shaded-in areas are where the black is supposed to be placed and the dotted lines are where the red is placed. I used two different types of dotted lines, one for the red and one to show where a thin black line is placed.

All the designs illustrated in this book are original designs and for use in this book only. They are not to be copied for sale or for use on any public regalia or events without written consent by me, Robert E. Stanley Sr.

Robert E. Stanley Sr.
2003

```
................. = thin red line

--------- = thin black line

[▨]  = Place black here

[⬚]  = Place red here
```

The Owl
k'utk'unukws

The Owl is a sub-crest of a killer whale house on the Nass River, B.C. They are nocturnal birds of prey. There are many different stories about this crest, some about good luck owls and bad luck owls. The k'utk'unuks is an owl crest.

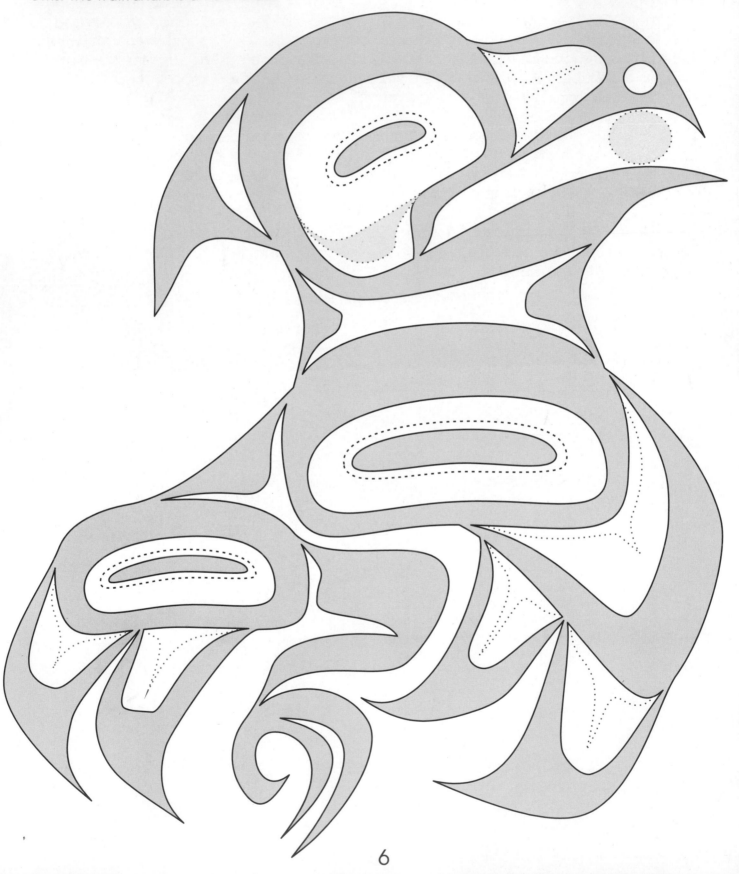

The Killer Whale
ṅeekhl

The Killer Whale is a great hunter of the sea. Killer whales always travel and hunt in pods. That is what families of killer whales are called. Their favorite food is fish. Killer whales also like to hunt sea lions, They will swim up on the shore or a rock just to get at one.

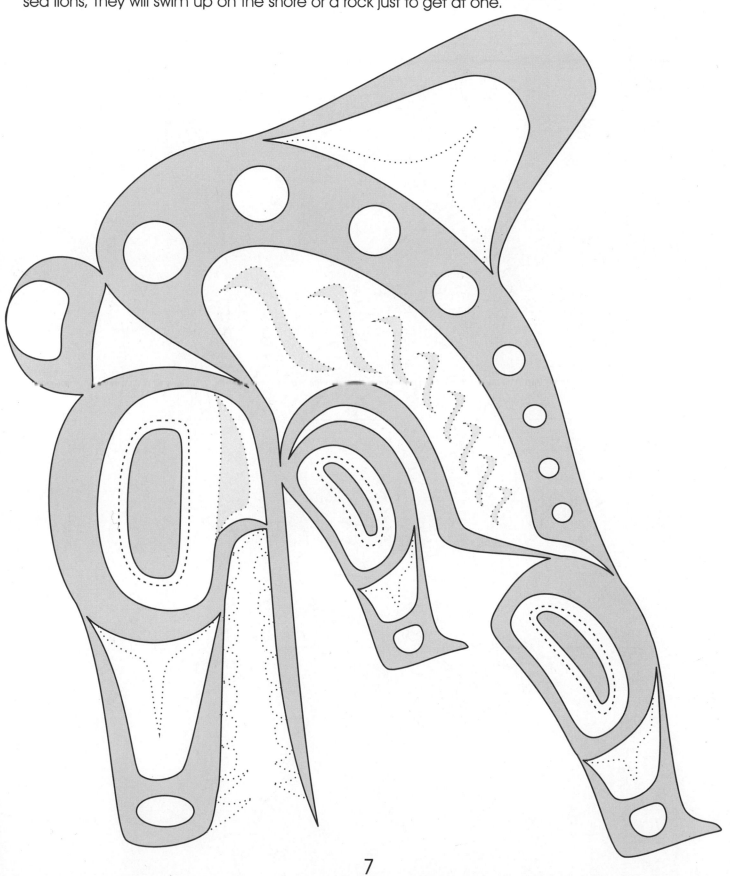

The Wolf
gibuu

The Wolf is a clever hunter. When hungry, they form a pack and take turns chasing their prey until the prey gets too tired to run. After the prey is caught, the alpha male (the leader) gets to eat first, then the rest of the pack take their turns. The strongest ones always get the most food.

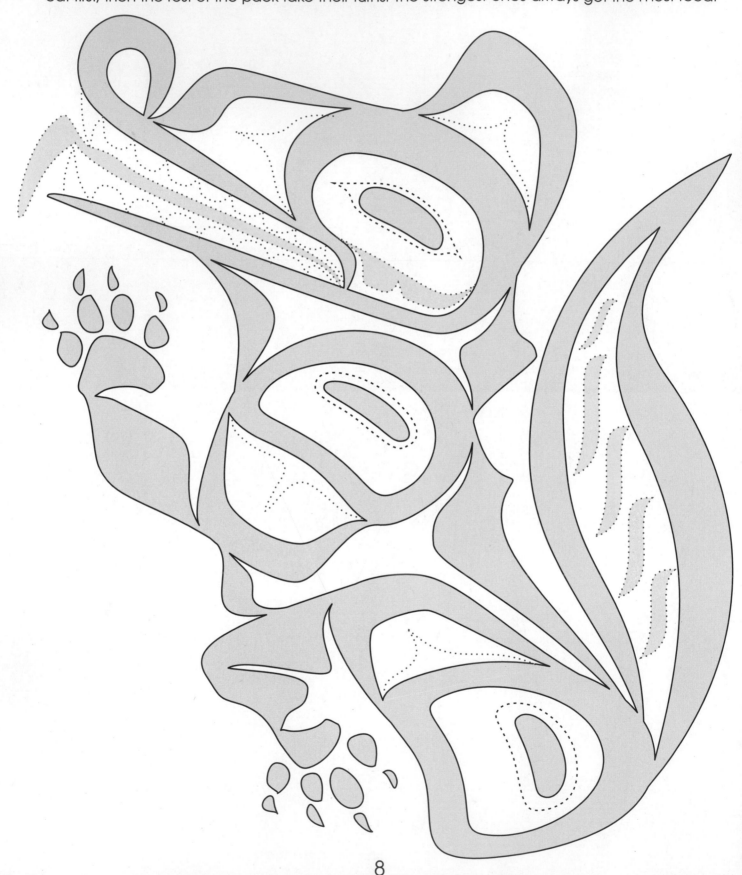

The Frog
g̲anaaẃ

The Frog is a part of the raven clan. They live in shallow ponds. The ponds they live in are always very warm and usually full of all kinds of bugs. That is their favorite kind of food.

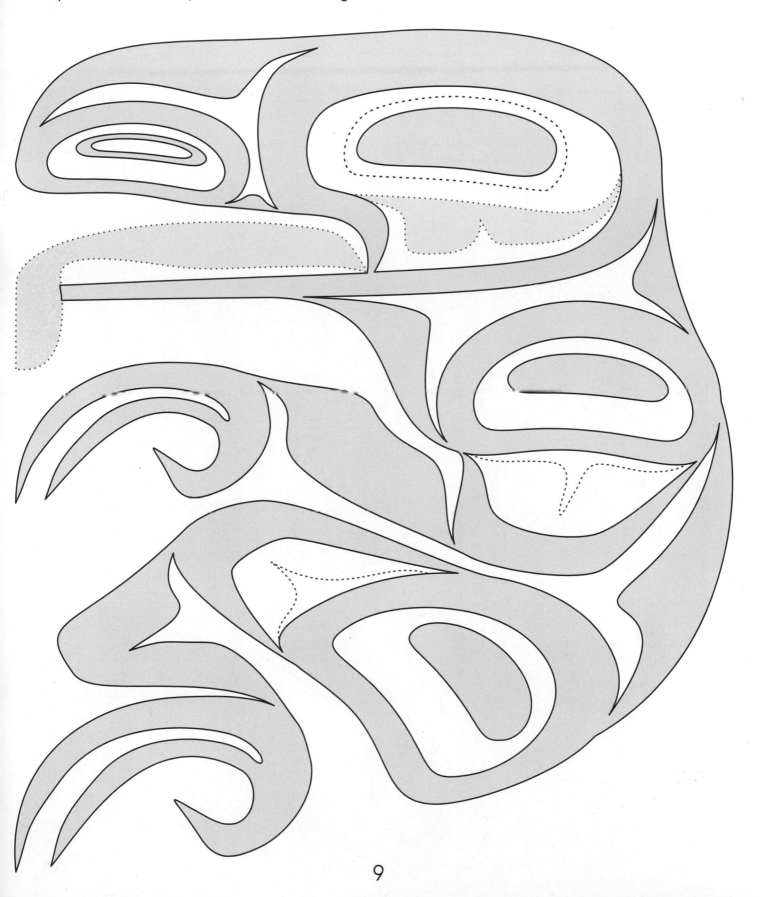

The Eagle
xsgaak

The Eagle is a very majestic bird and is a symbol of power and prestige. Their favorite food is salmon. I like to watch them fly around in circles on a clear day. When they mate they look like they are fighting in the sky. They grab each others' claws and fall a little way, then they let each other go.

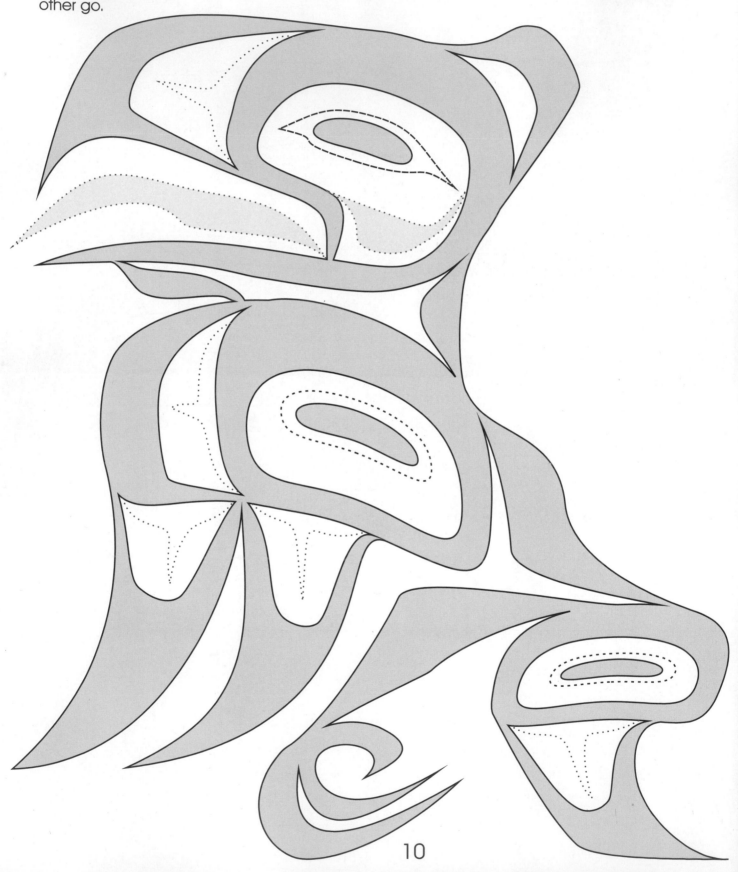

The Moon
hlok̲sim ax̲kw

A full moon usually means that a month has passed and a new one is about to begin. It also lights the path at night for night travelers. This face represents the man in the moon. This design is colored in turquoise blue with red fillers. The eyes and eyebrows are black.

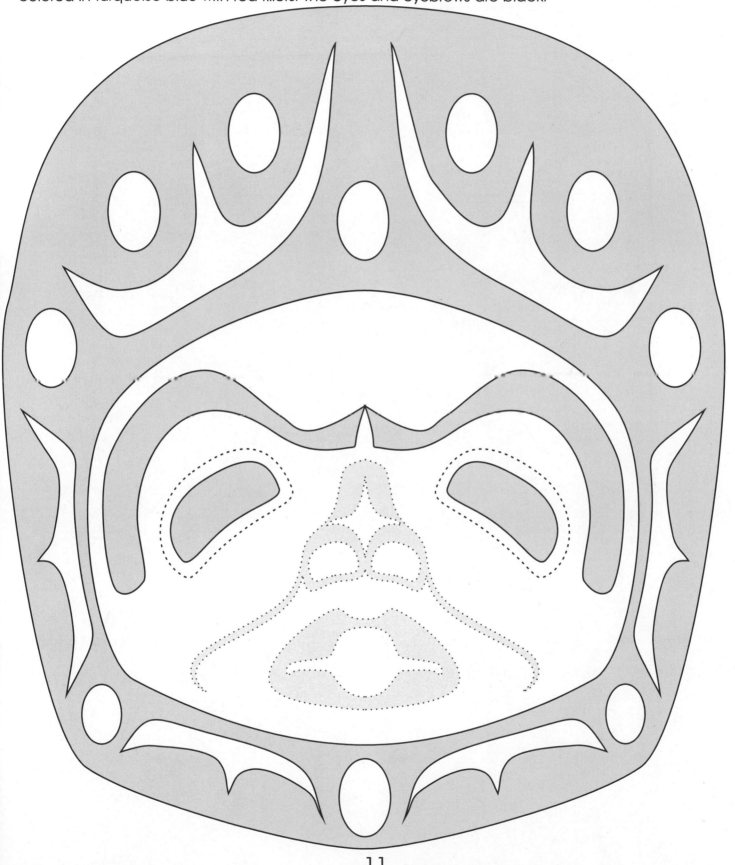

The Grizzly Bear
lik'inskw

The Grizzly Bear is a powerful animal. This crest represents power and strength. A grizzly bear's favorite food is salmon. They also like to eat different kinds of berries such as salmon berries and blueberries.

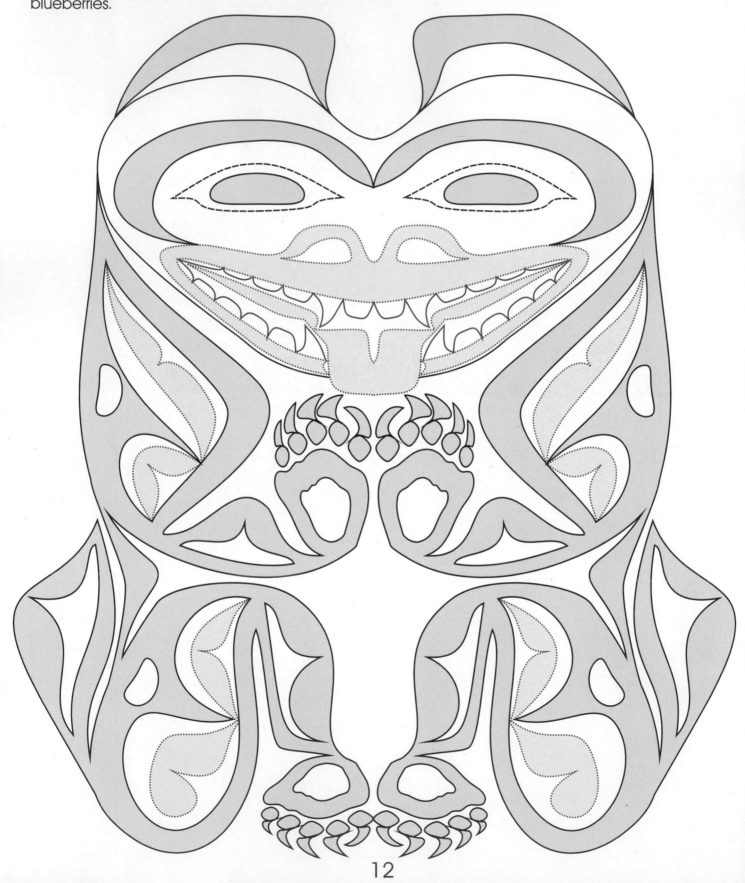

The Sun
hlo<u>k</u>s

The sun is our source of light and helps all things to grow. Too much sunlight would dry things up. It is good that we have just the right amount of sunlight.

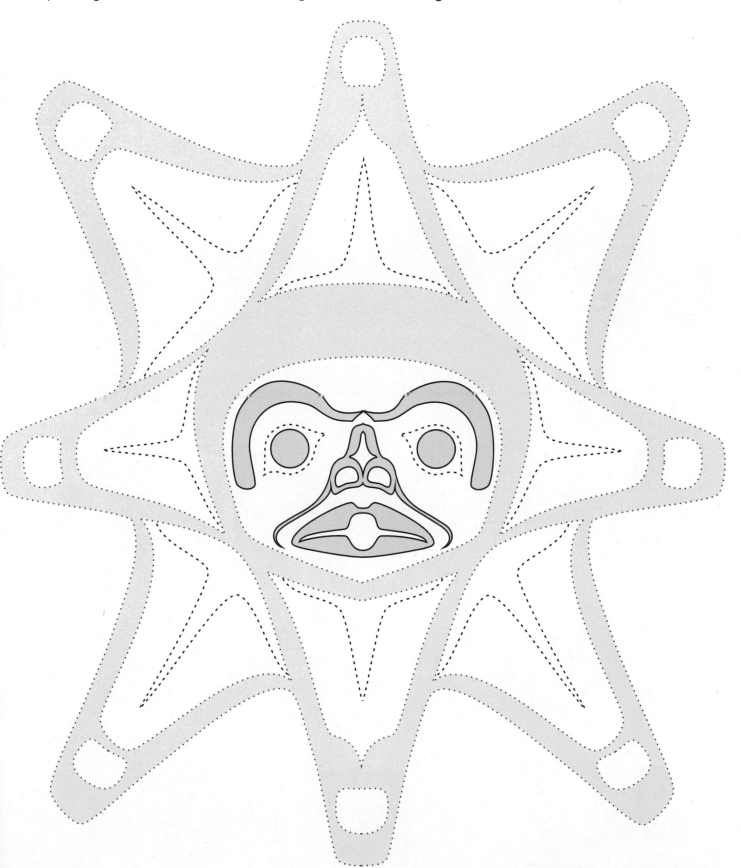

hlo<u>k</u>s

13

The Black Bear
ul

The Black Bear is similar to the grizzly bear, but is not as big and powerful. They like to eat the same things and they hibernate in the winter just like grizzlies.

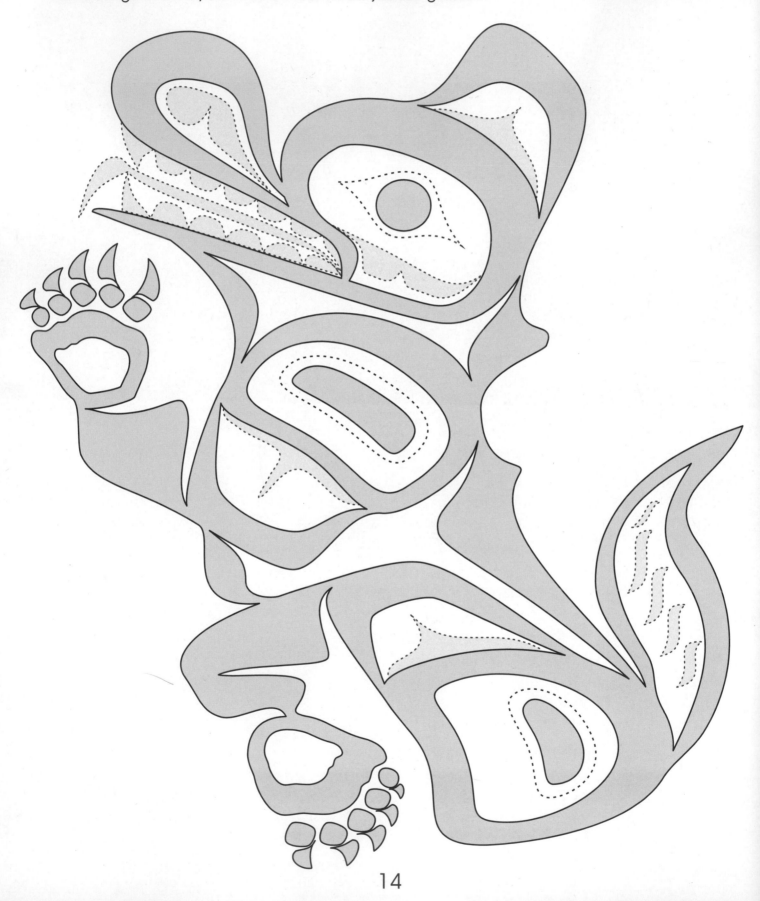

The Raven
g̱aaḵ

There are a lot of stories about the raven. He is a mischievous trickster, who likes to have fun at other people's expense.

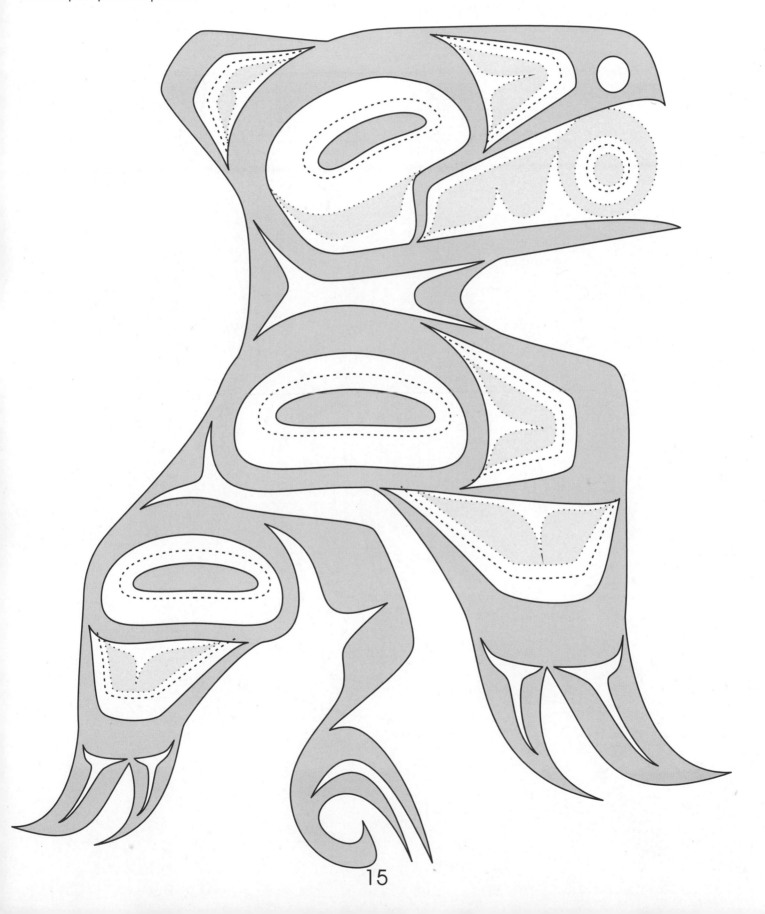

The Male Salmon
miso'o

I use this design to represent prosperity and fertility. Prosperity because, in the old days, the more salmon that a family or tribe could gather in the summer months, the wealthier they became. Fertility because salmon can produce thousands of eggs at one time.

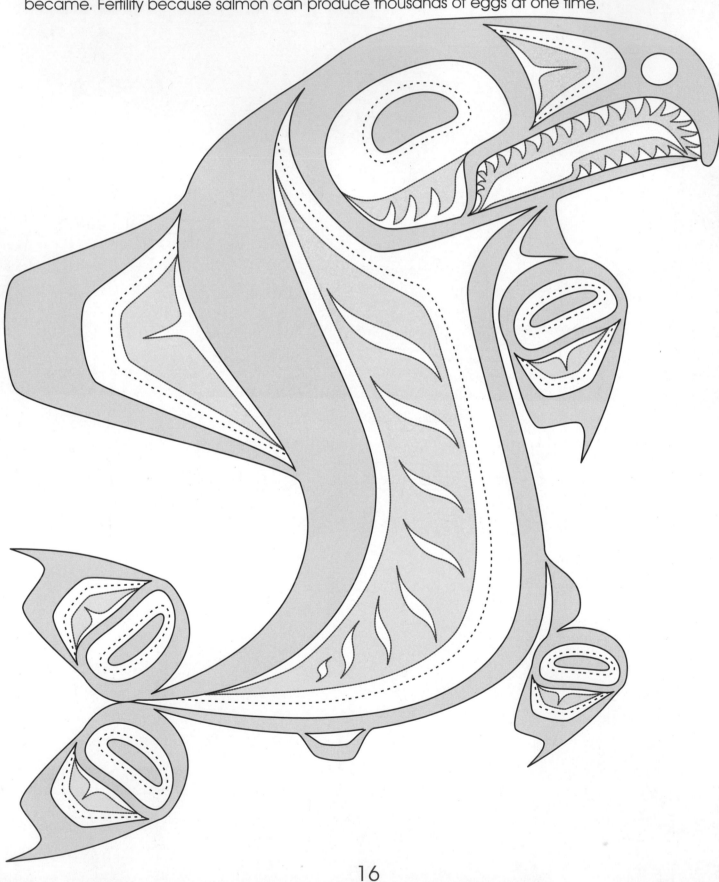

The Female Salmon
gitl'

The difference between the male and female salmon is the female does not have a turned down or hooked nose like the male. I always like to draw the female spawning or laying her eggs to represents her fertility.

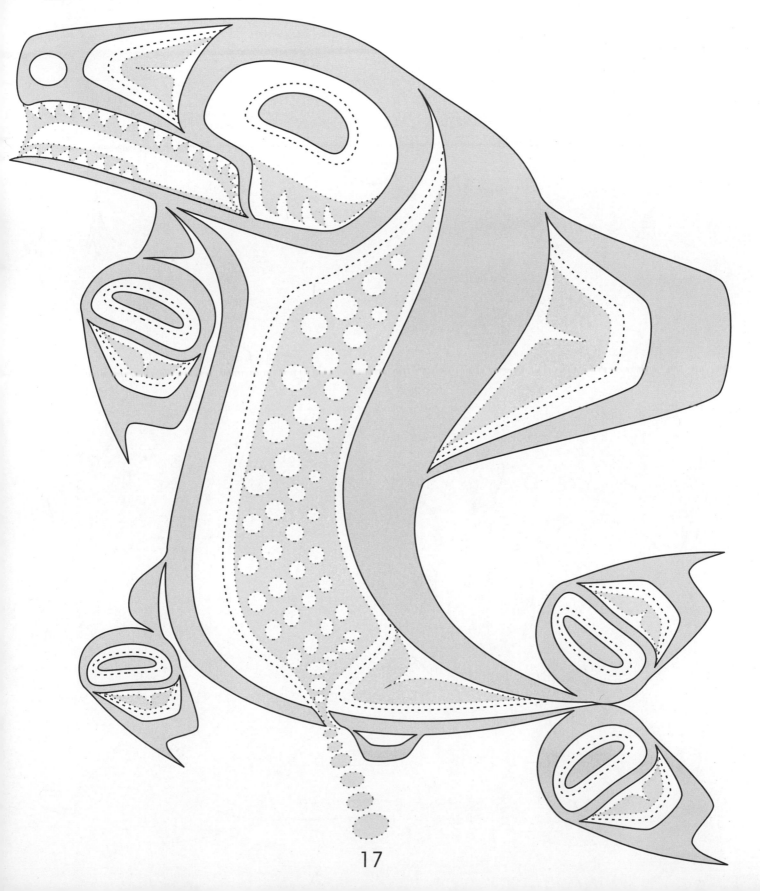

The Beaver
ts'imilx

The beaver is always a hard worker and likes to get the work done. This is another powerful crest to have. They are slow, methodical and very patient with their work.

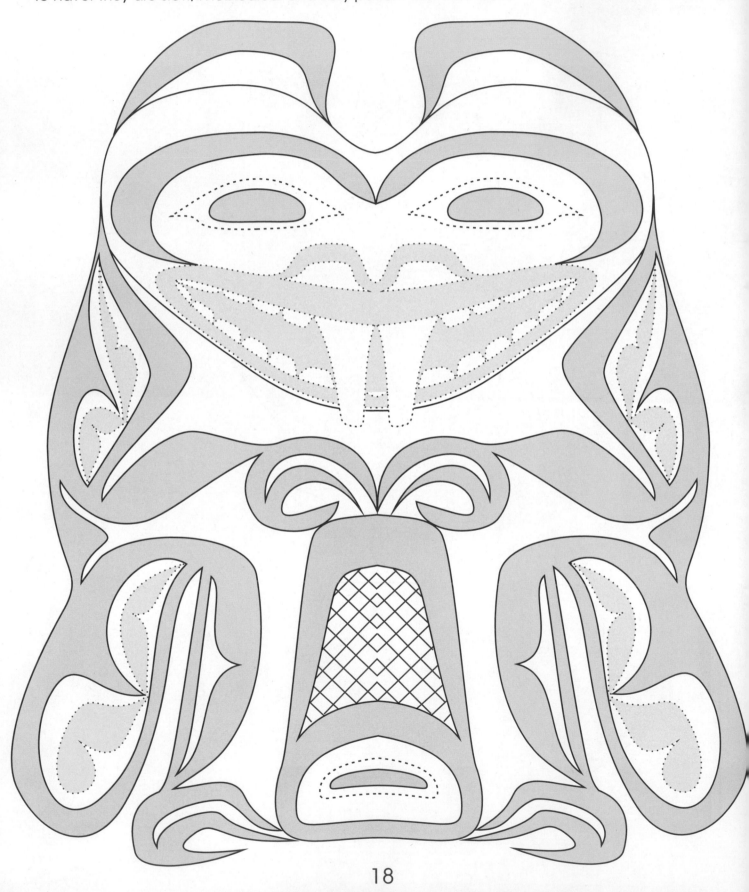

The Diving Frog
suuḵsgum g̱anaaẉ

There are many different frog crests that belong to different families. They are drawn differently because each family has a different story behind their own family crest. I called this one the diving frog because that looks like what it is doing.

19

Face in an Ovoid
ts'aḷ

The face in the ovoid is one of the ways I fill in an ovoid. The kind of face I can put in the ovoid depends on the design of the original crest.

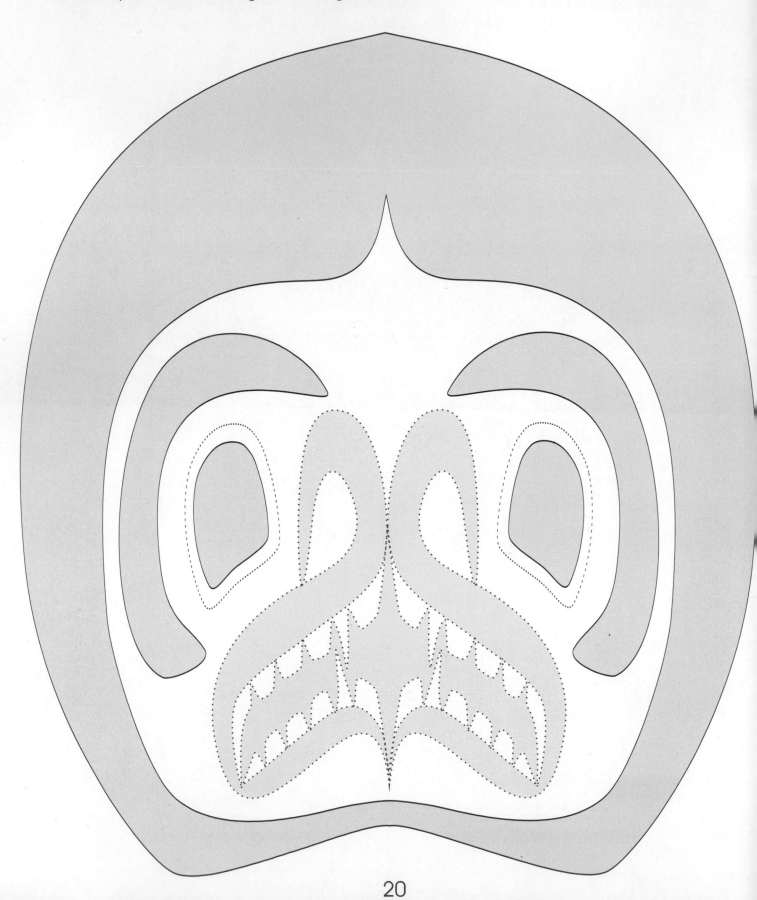

The Split-Frog
bayt bahlgum g̲anaaẁ

This is another frog crest design. It is a frontal design that can be used on house fronts or on the front of bent boxes.

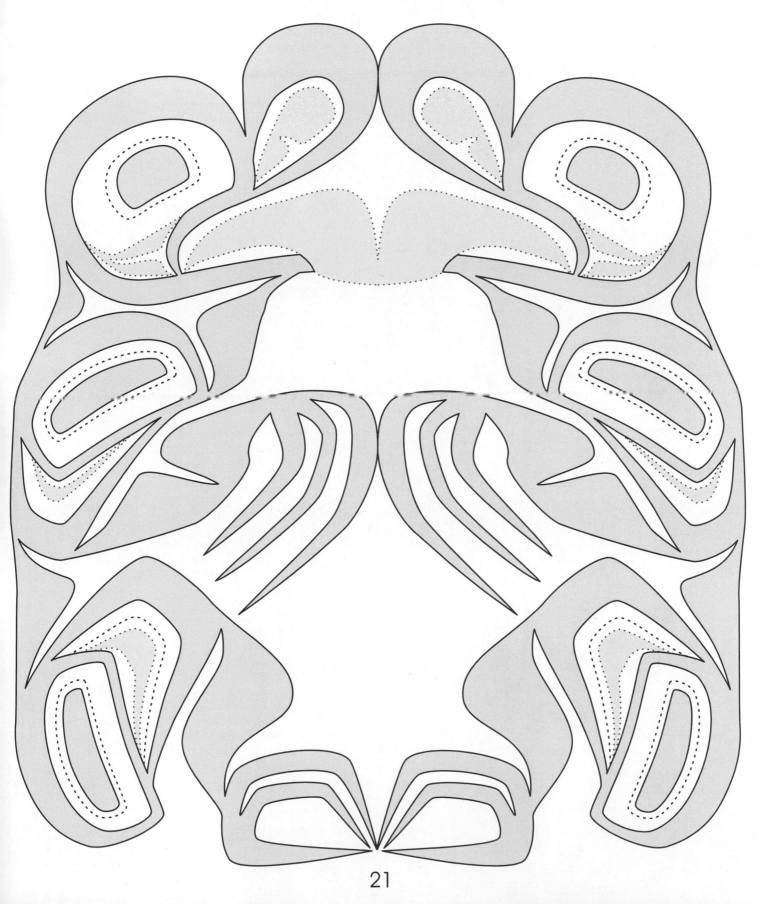

The Raven and the Sun
t̲xeemsim

This design is a very popular one. It represents the raven releasing the sun after stealing it from an old shaman who kept it hidden in a box. The raven is also part of the frog clan.

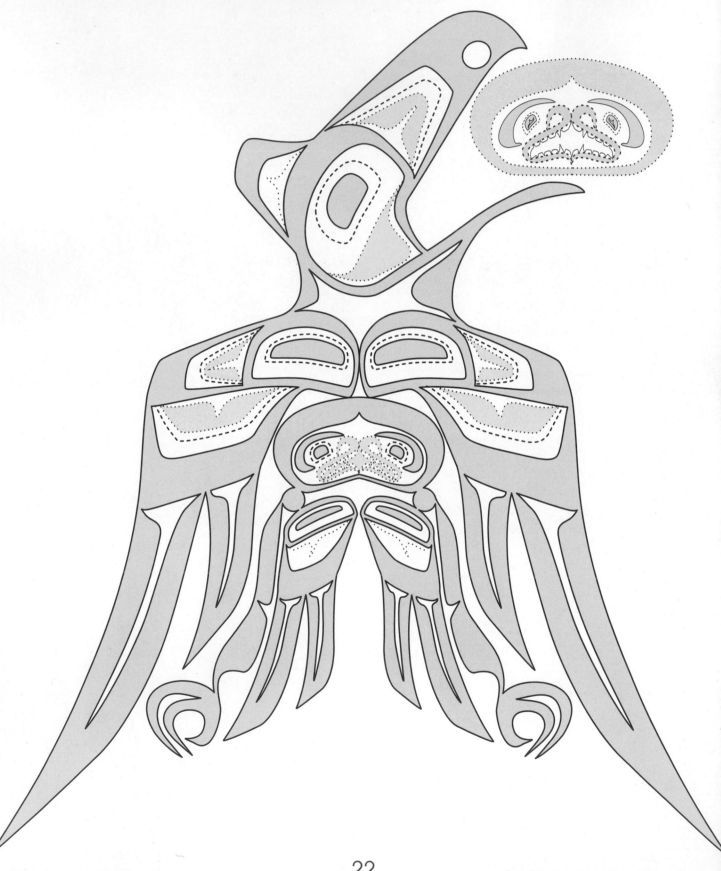

The Wild Man of the Forest

This is the wild man of the forest. He is the one that takes little children if they stay too late in the woods at night. That is why nobody wanders around in the forest at night. When stuck in the woods at night, they must build a fire and make camp. Someone must stay up to keep guard and watch over those who sleep.

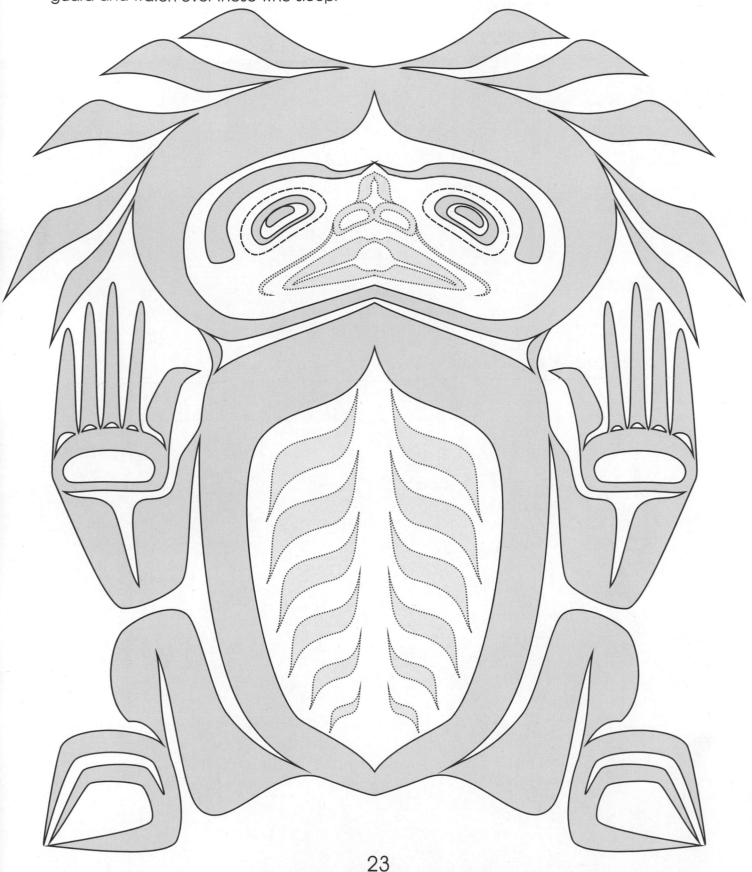

The Hawk
ts'ik

A sharp eyed bird of prey. Their favorite food is the little lemming. They are very good hunters and can spot their prey from high in the sky. It also represents someone who is good at selling things.

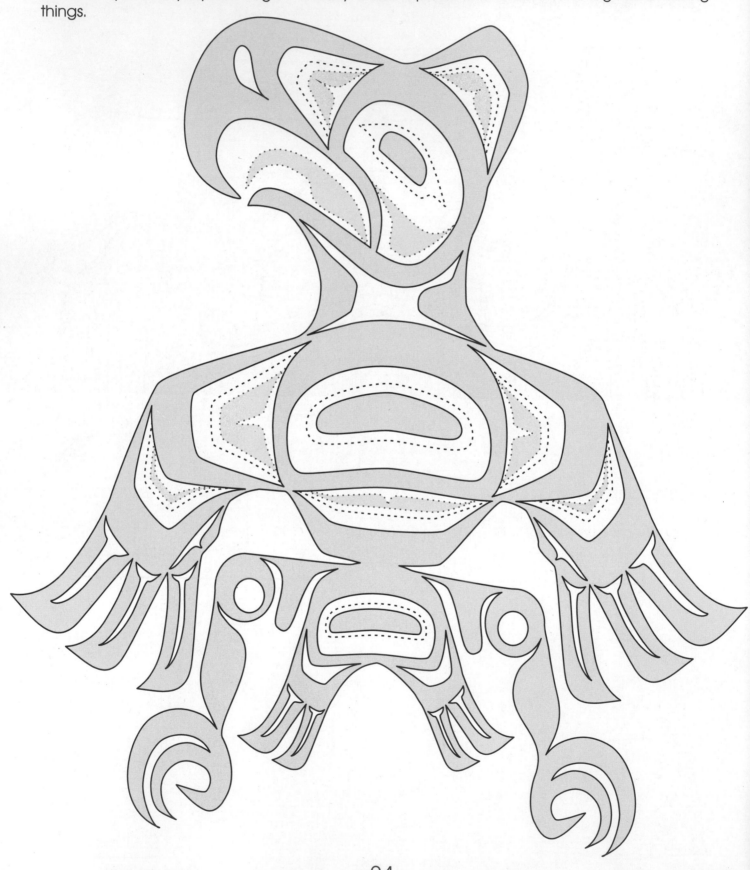

The Prayer
giginax̱kw

I called this design the prayer because the man is in the kneeling position with his hands up in a praying position. He is also looking up a little.

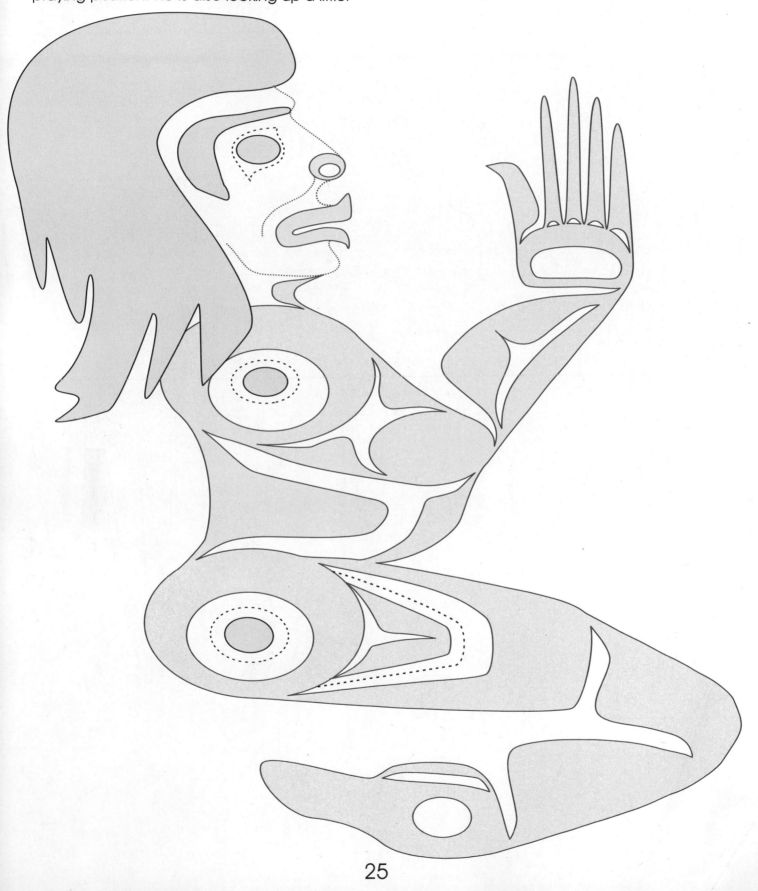

The Flying Frog
gibaygum ganaaẃ

Another frog crest design. This is the house crest my wife belongs to. I did this design and placed it on her wedding dress and on the coat the women of my family gave her on our wedding day. Giving her a coat on our wedding day meant that she is accepted in our family. It is just one of our cultural traditions we perform at weddings.

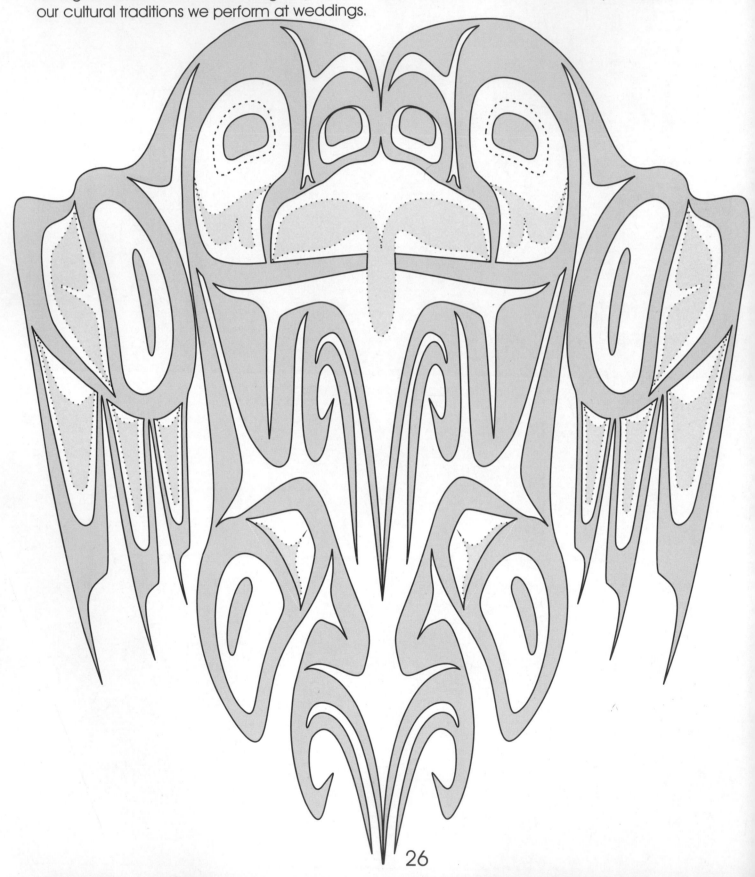

26

The Robin and The Twig
soo<u>k</u>

The robin and the twig is one of the crests that belong to a frog clan of the Nishga'a nation.

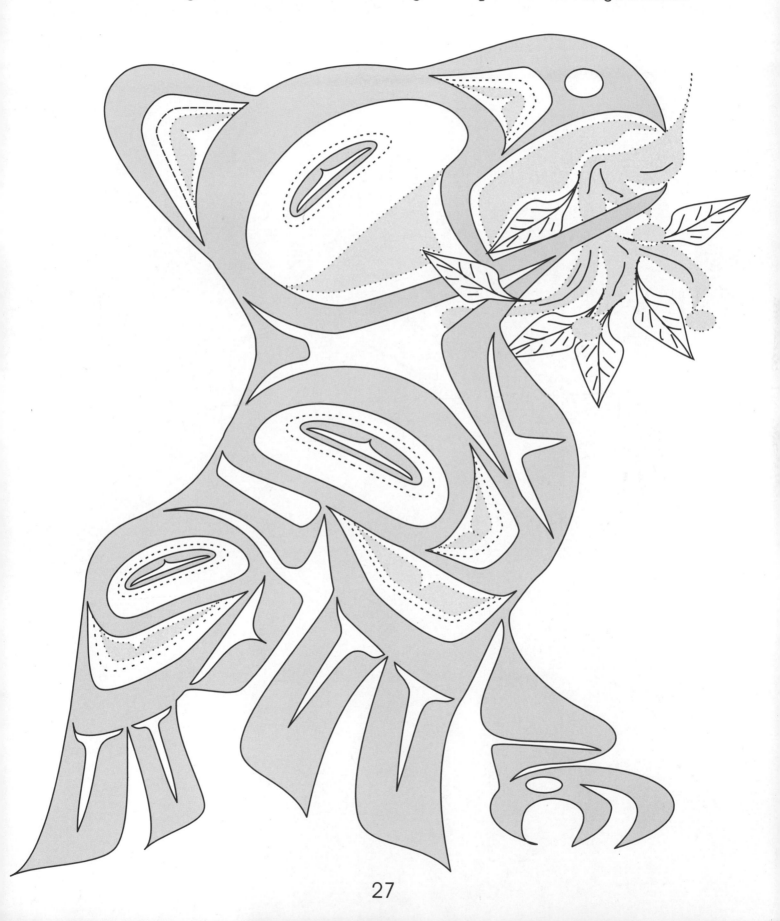

The Kingfisher
ts'iyoolik'

I just drew this design because I liked it and wanted to see if I could. It was sort of a personal challenge on my part. I think, from personal experience, that these birds are a nuisance to fishermen.

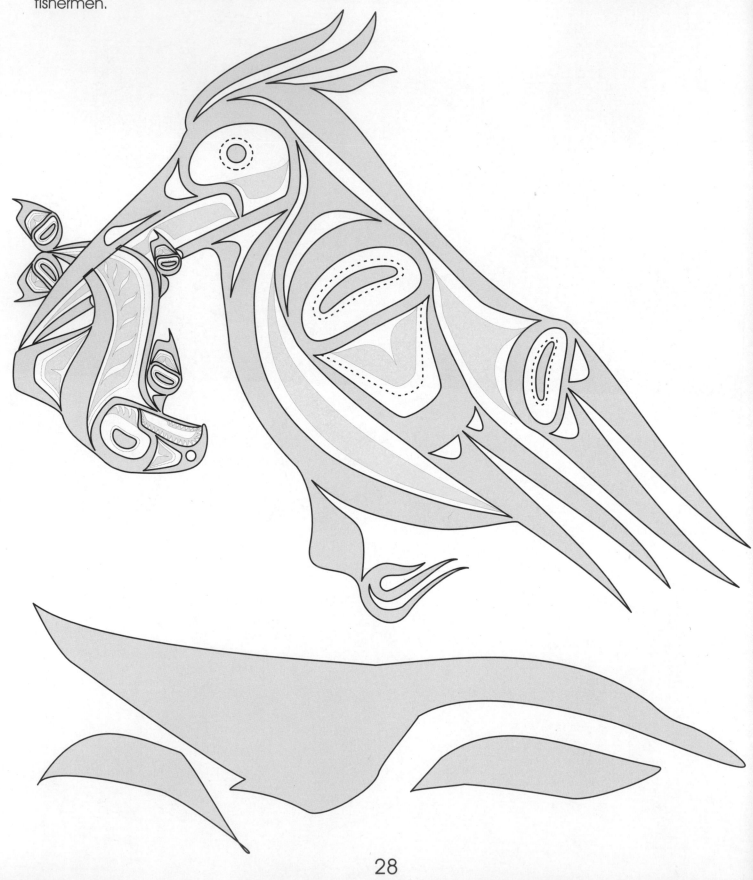

The Crab
k̲'almoos

One of our favorite foods. They are easy to catch and cook. The only thing to watch for is their sharp pinchers. Don't let it grab you with them because they are very strong and a pinch can be very painful. The crab can also mean someone who is a grouchy person.

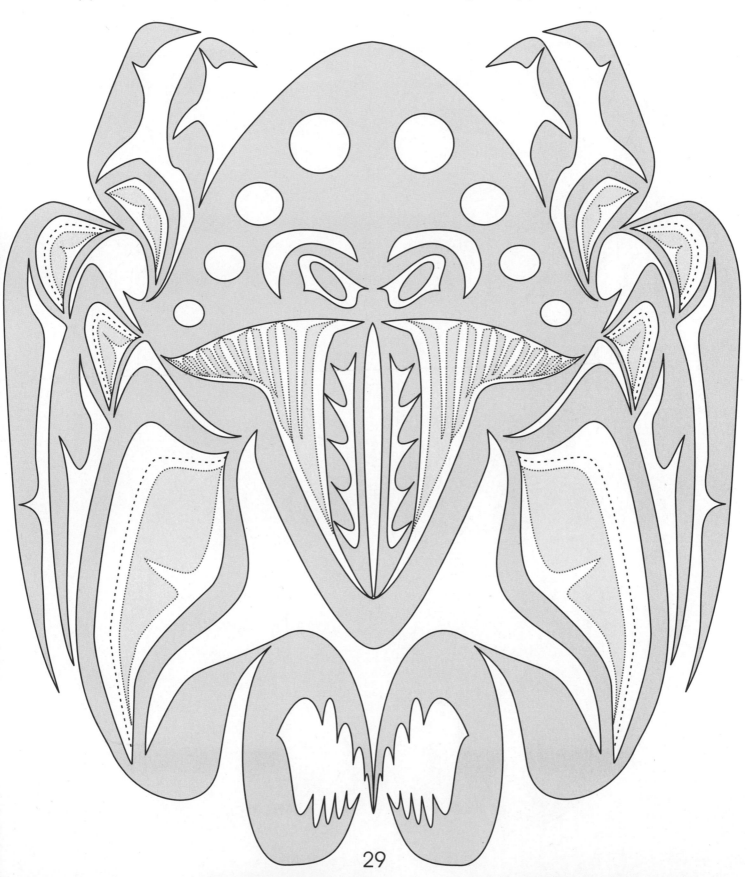

The Timber Wolf
sim gibuu

The Timber Wolf is bigger and stronger than the normal wolf. They are found in the northern regions of North America.

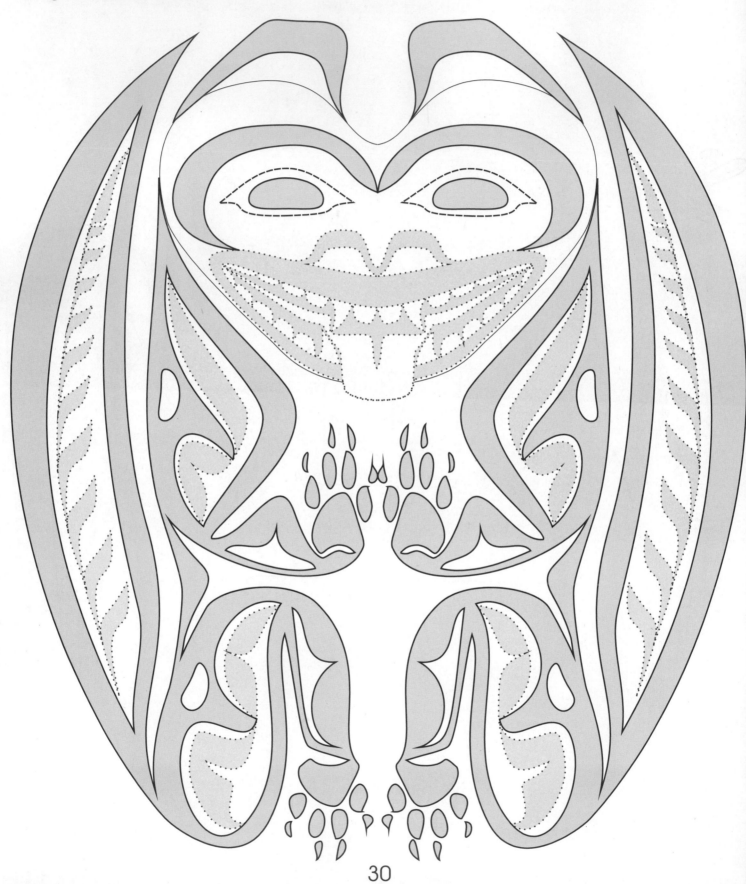

The Split-Killer Whale
bayt bahlgum ńeekhl

This design is the frontal view of a killer whale. The split-killer whale design belongs to the House of Ni'isyuus, a killer whale house of the Nisga'a nation. I am from the House of Ni'isyuus and this design is on my regalia.

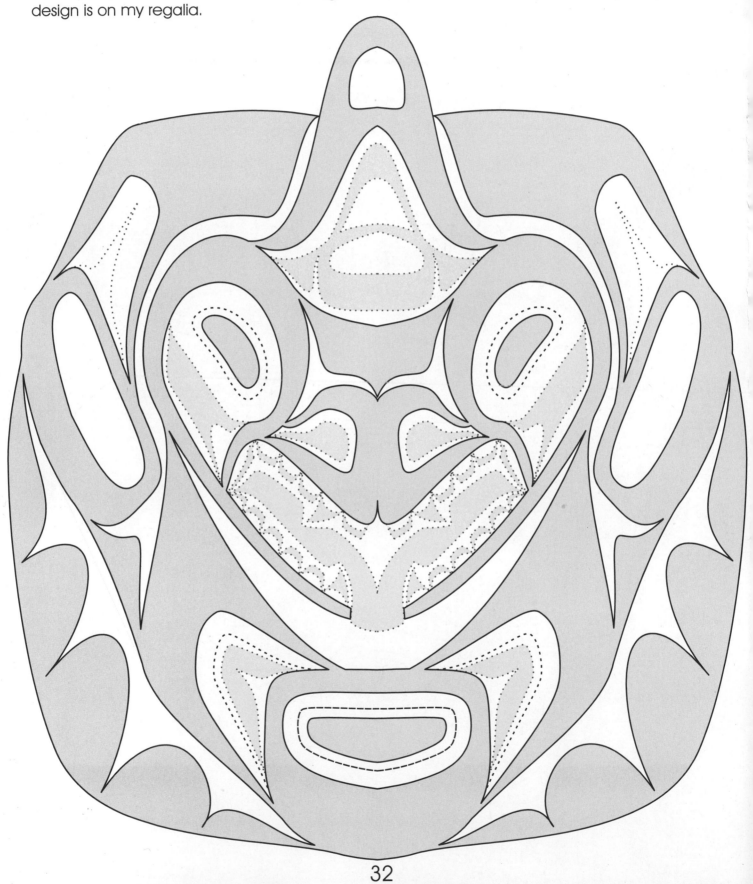

The Lizard
ksihlkw

This crest belongs to the people of Gitwinksihlkw from the Nass River, northern British Columbia. It can be found living on the lava beds.

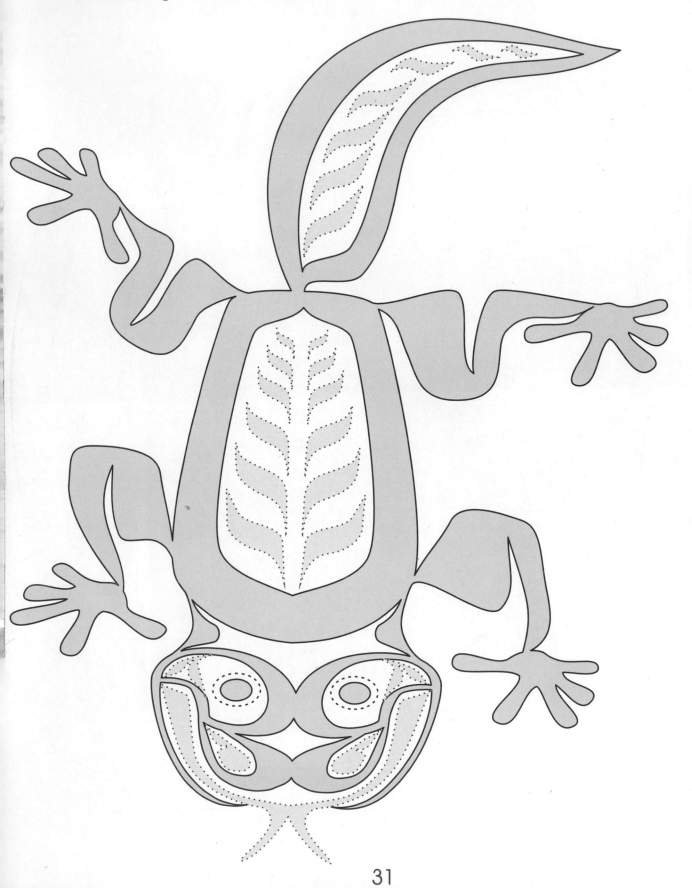